To Kevin –

Joyous Yuletide and

Merry Christmas!

With love from

Jenny, Dan, + John

2005

A DOG'S BOOK
OF TRUTHS

A DOG'S BOOK
OF TRUTHS

Photographs
NANCY LeVINE

Words
JOSEPH DUEMER

Foreword
RUTH SILVERMAN

Design
JON CANNELL

**Andrews McMeel
Publishing**

Kansas City

02 03 04 05 06 TWP 10 9 8 7 6 5 4 3 2 1

ISBN: 0-7407-2708-7

Library of Congress Control Number: 2002103643

ATTENTION: SCHOOLS AND BUSINESSES

Andrews McMeel books are available at quantity discounts with bulk purchase
for educational, business, or sales promotional use. For information, please
write to: Special Sales Department, Andrews McMeel Publishing, 4520 Main
Street, Kansas City, Missouri 64111.

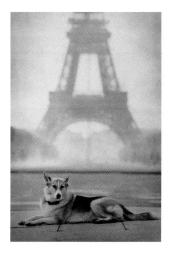

For Babe (1972–1988).

For my dad.

NANCY LEVINE

In memory of Mingo—"good boy"—and for Penny, Maude, and Weezer.

JOSEPH DUEMER

FOREWORD

Much censure is given those who tend to attribute human behaviors and feelings to animals. Nancy LeVine's photographs say both sides are wasting time. She makes it perfectly clear that, with no help from us, dogs are as busy and curious as little children and as sensitive as a good grandmother. Like us, but with no need for hats and shoes, they wander and investigate the landscape, check out city streets, enjoy the company of old friends and the meeting of new ones, ponder the odd nature of cows, and love ice cream cones. Dogs question the need for baths, are lonely when alone, and love hugs. On a really great day, with no other pressing commitments, a dog will lie contentedly on a high bluff, overlook the world, and think stray thoughts.

We have an abundance of documentary photographers, but Nancy is an exceptionally fine and observant one. With the essential elements of composition, light, and nimbleness under her complete control, she adds variety, surprise, and warmth. In the tradition of the great French romantic street photographer Robert Doisneau, and the American Helen Levitt, perhaps our best recorder of small and telling moments, Nancy's work is natural and authentic. She sees the best of what's to see.

We'd each be extremely fortunate to have Nancy LeVine make a photo of our dogs or our friends. What's the difference?!

RUTH SILVERMAN
Editor, *The Dog: 100 Years of Classic Photography*

The Way I See Dogs

My work, at its core, involves an obsession with two individuals who happen to be dogs. For almost a decade, I have chronicled two lives with a passionate attention that is generally reserved only for lovers. This dedication over time has been a deliberative effort, a creative involvement that has not only consumed me as an artist, but taught me elements of visual and emotional nuance that I could in no other way have felt so intimately.

The intensity with which I have pursued this obsession has conditioned me to be ever on the alert for that perfect unself-conscious moment that transcends superficiality or artifice. My work with the dogs has taught me to explore those moments of significance that I intuitively feel are present but which I do not profess to fully understand. I never start from the position of negotiating my subjects into places or costumes or poses. I look for what is already there, and I know I have found what I am looking for at that perfect unself-conscious moment, untainted by any superimposed convention. It is that moment that attracts me: that subtle moment of revelation.

My work grows out of persistent devotion to two subjects and in the process, I have learned a way of seeing. The resulting body of work is intended to take its place in the tradition of the dog in art, and to capture the truths that are reflected in these images. My work with dogs has shaped the way I approach all my subjects, that is, those who stand on two legs as well as on four. This work has given me a drive to get to the core of things, to see what is really there.

NANCY LEVINE

The wonder of exquisite collaboration. *Thank you.*

NANCY

THERE ARE SOME SIMPLE TRUTHS

INSIDE THE WORLD'S COMPLEXITY

and the dogs know what they are. ❄

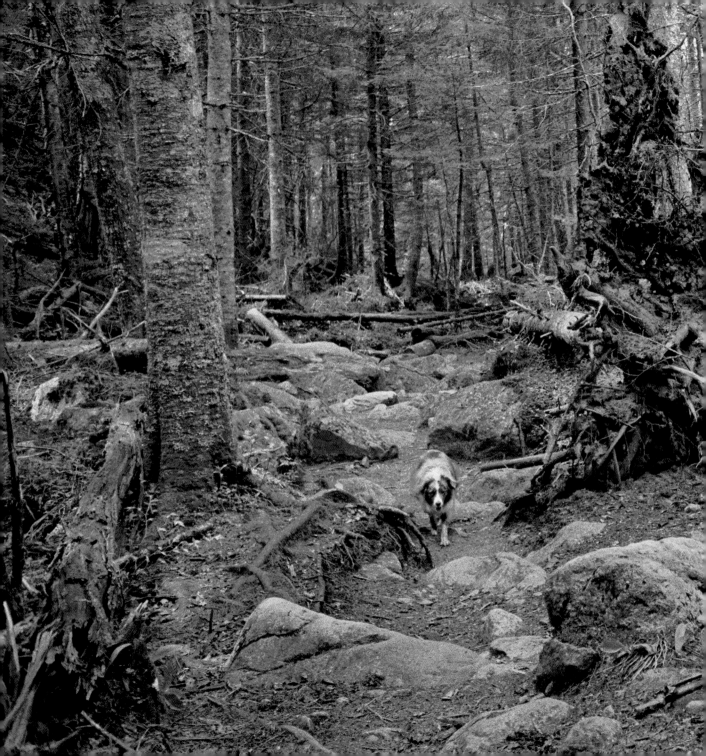

THEY UNDERSTAND
SIMPLE SENTENCES
BUT MAKE JUDGMENTS
based on sensual forms of trust. ✴

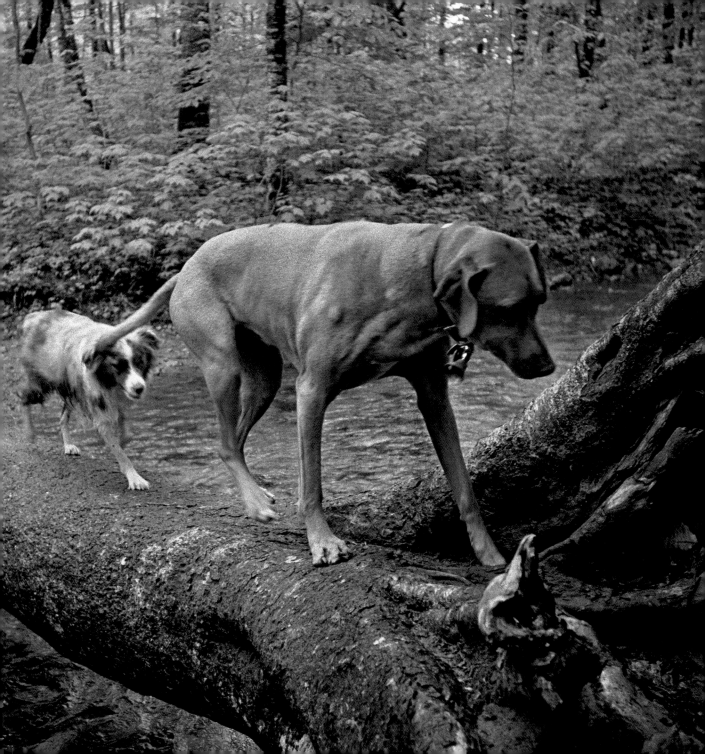

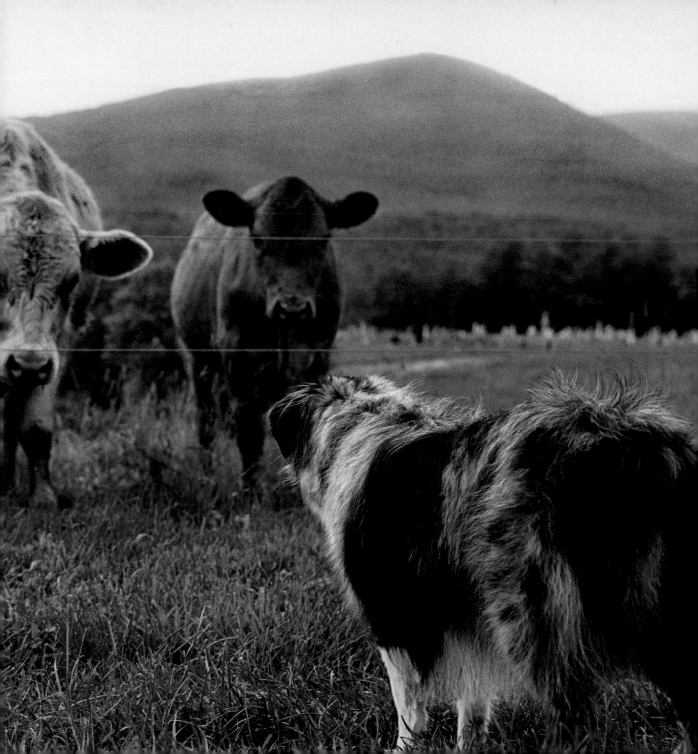

A DOG WITH HER NOSE

RAISED TO THE BREEZE

SURPASSES EVEN A SAINT

in the purity of her concentration. ❊

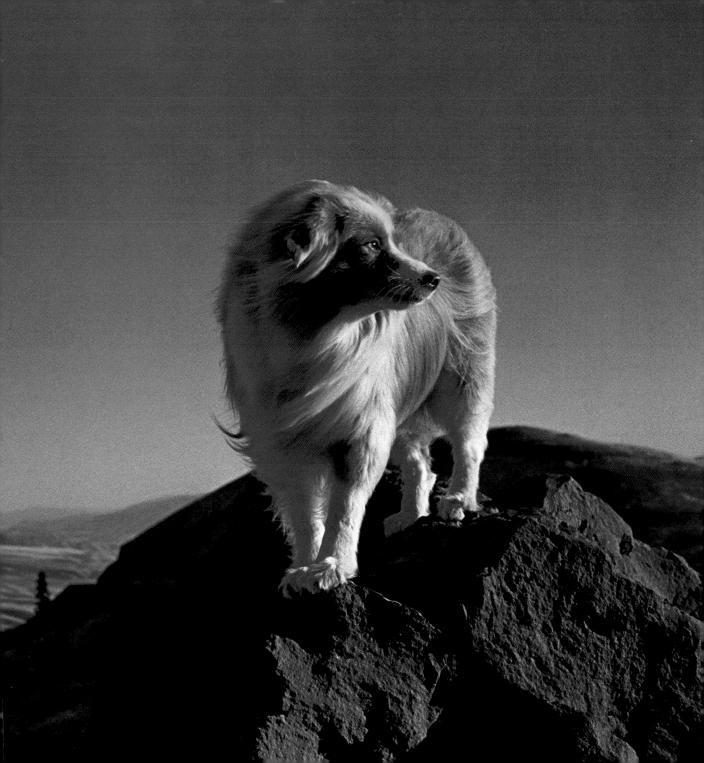

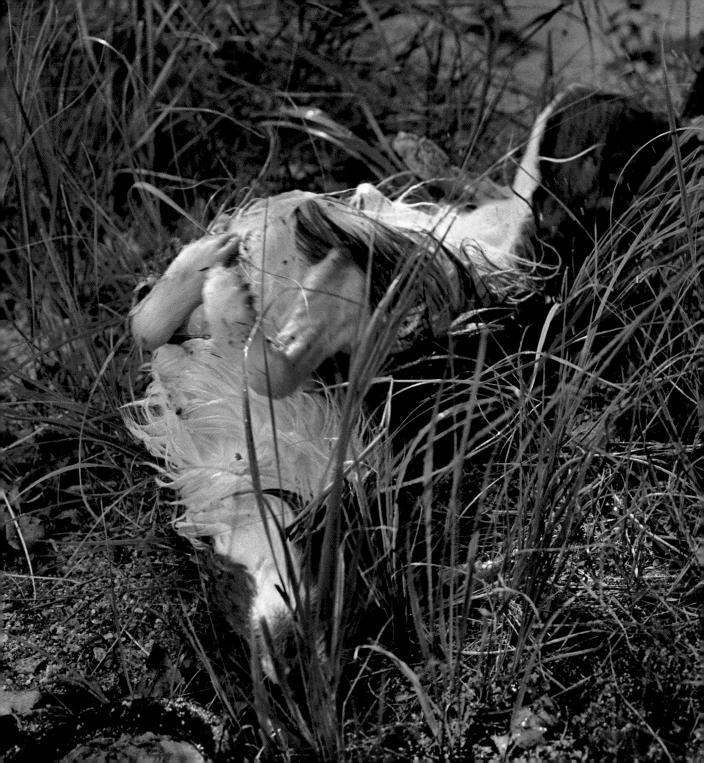

WITHOUT WORDS,

not without imagination. ✻

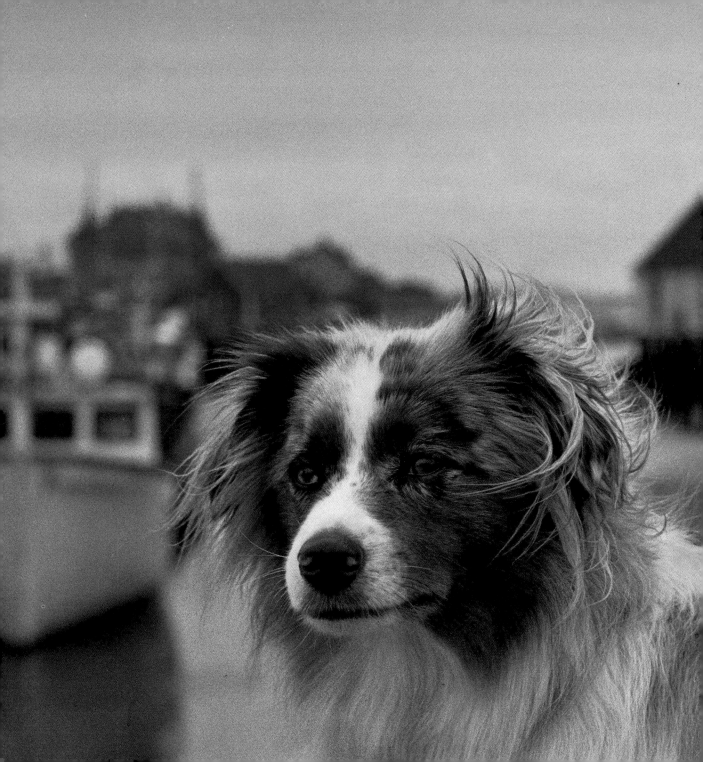

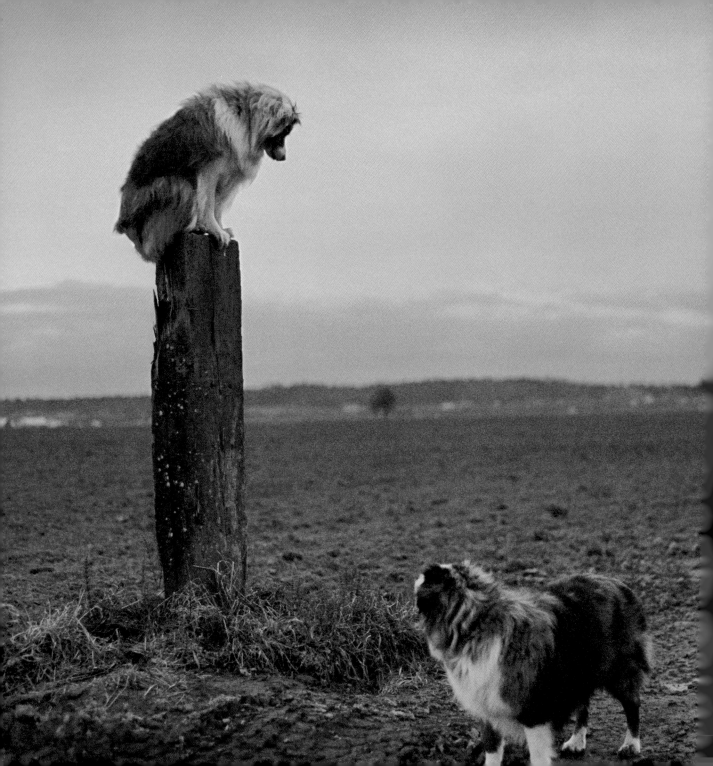

THE FAMOUS AND VEXING DIVIDE

BETWEEN MIND AND BODY

SUPPOSED BY PHILOSOPHERS

has no entry in A Dog's Book of Truths. ✳

The passion of dogs is pure, THE MEDITATION
OF DOGS SERENE. ❋

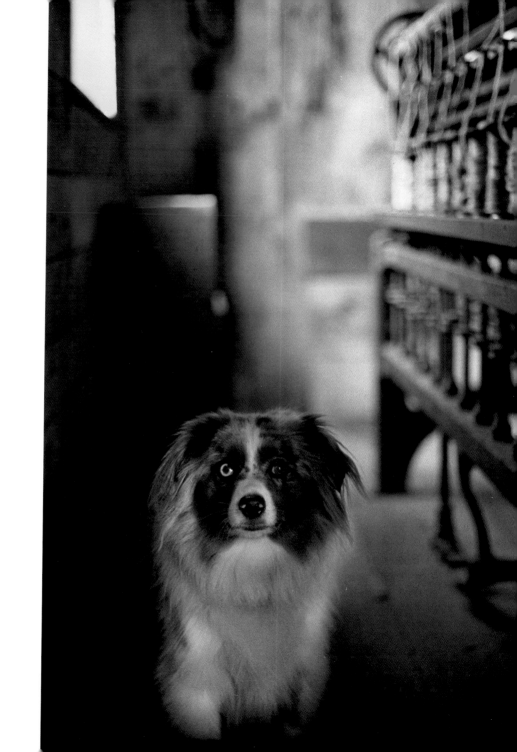

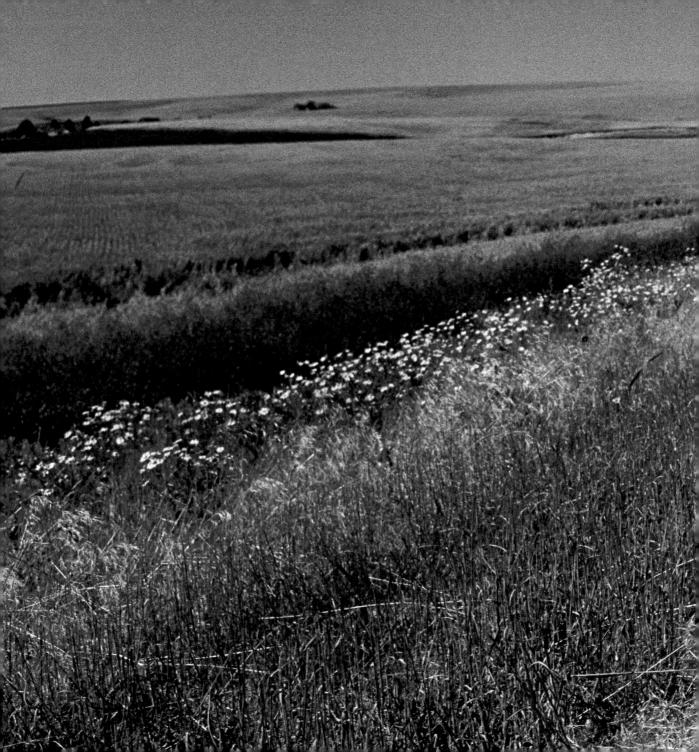

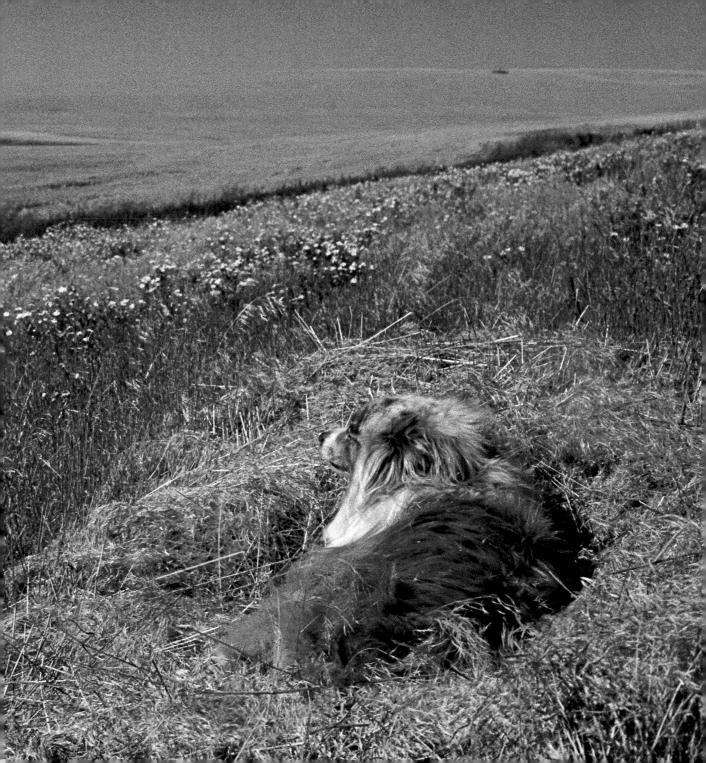

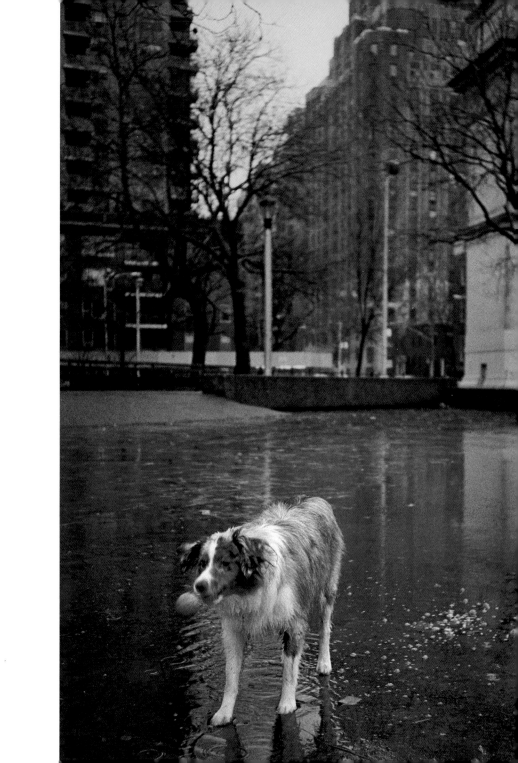

Their world is no doubt simpler than ours

BUT PROBABLY DEEPER

AND HAPPIER. ❊

SOME DOGS ARE COMIC

GENIUSES *precisely because they*

take the world so seriously. ❋

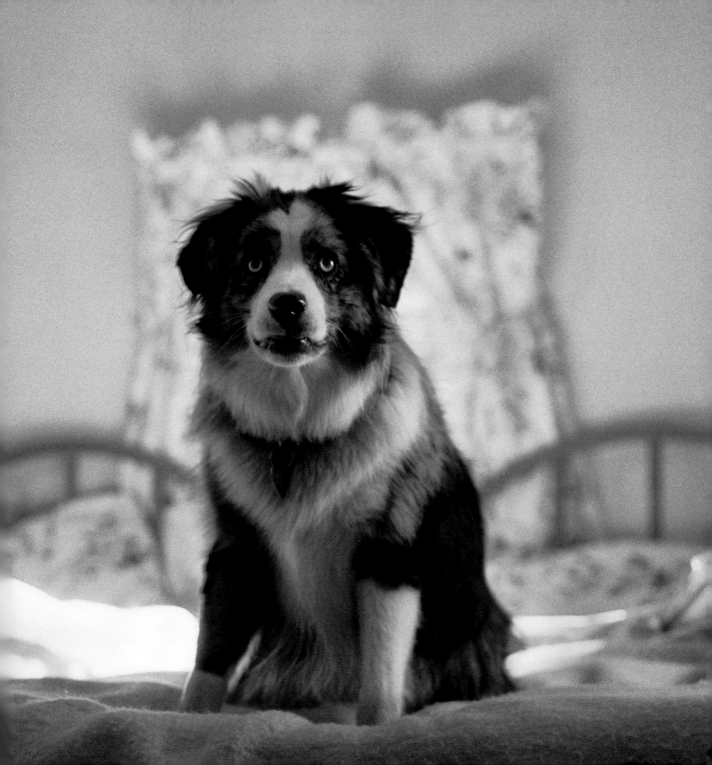

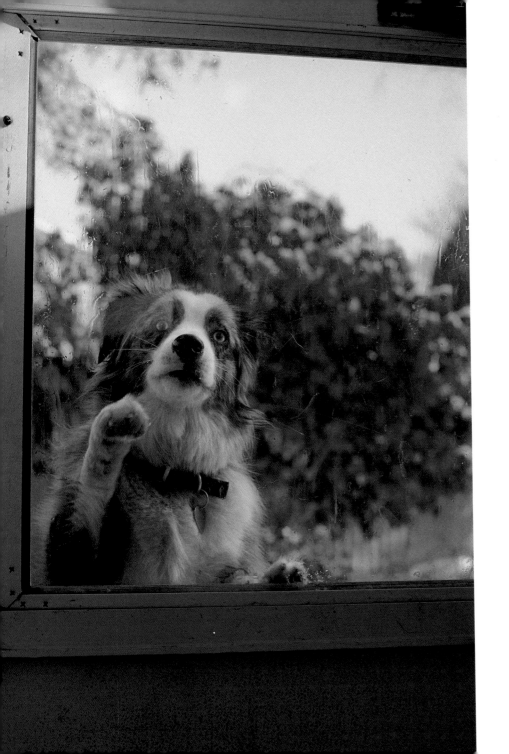

WITH NATURAL INTELLIGENCE

AN ABANDONED DOG

if she has the chance WILL CAREFULLY

SELECT HER NEW OWNERS. ❀

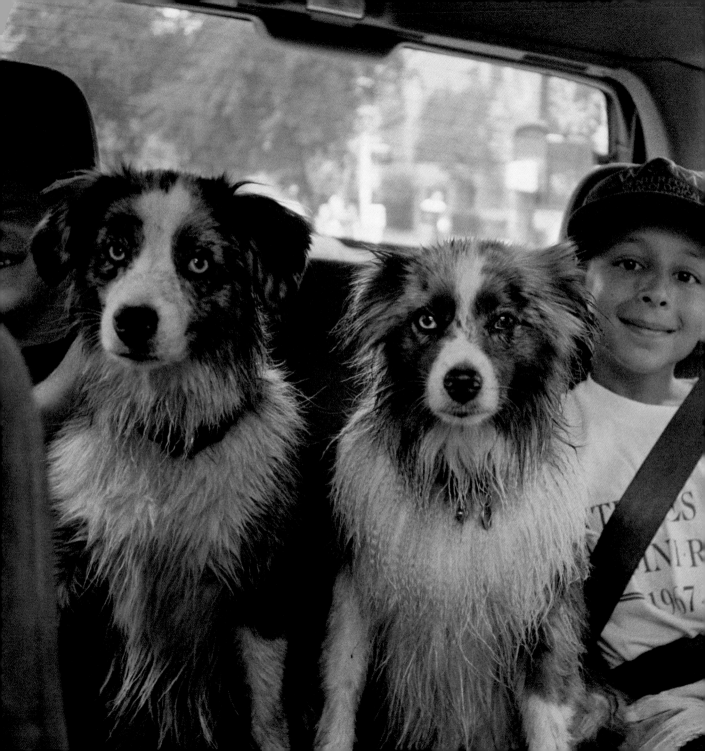

It is one of the astonishments of history THAT WE

HAVE ESTABLISHED SUCH SYMPATHIES

ACROSS THE DIVIDE *of* SPECIES. ❋

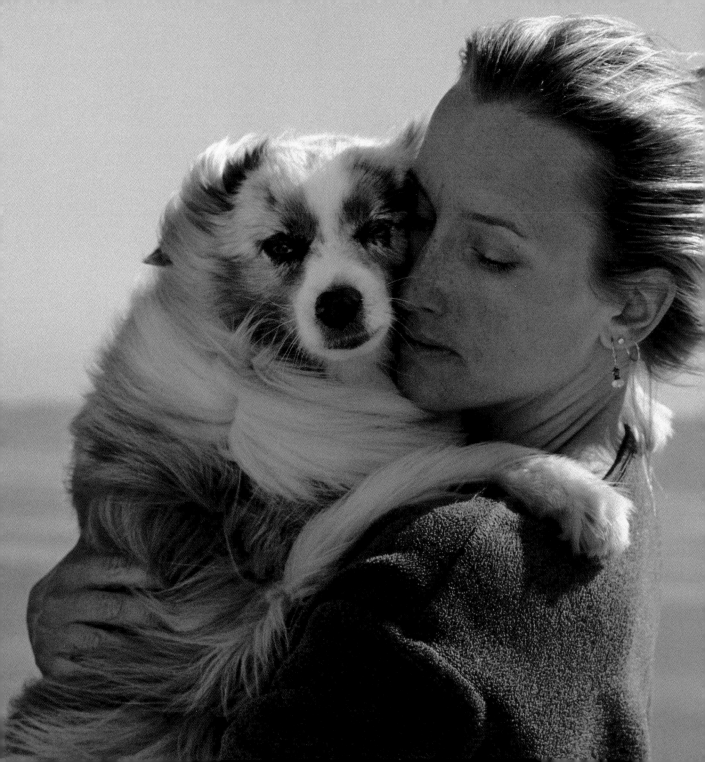

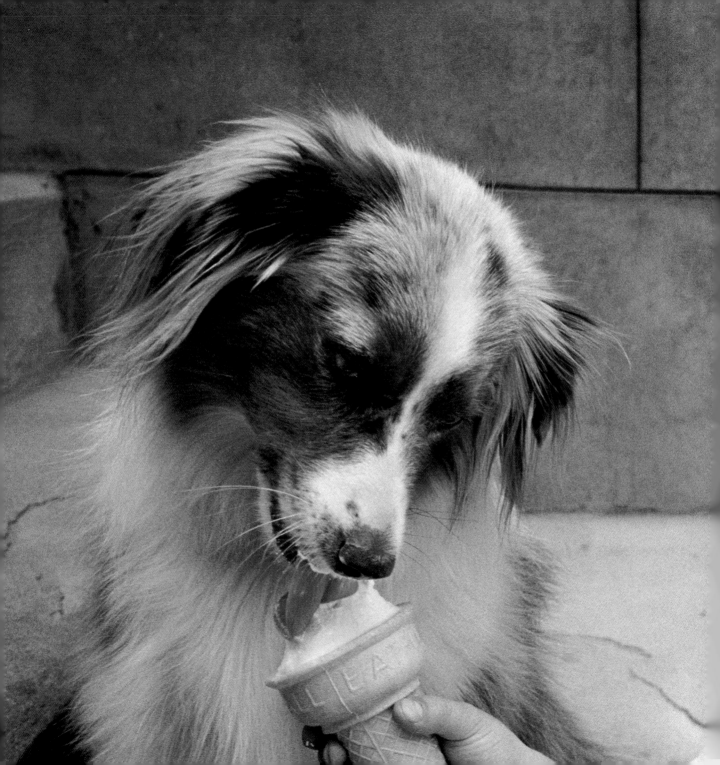

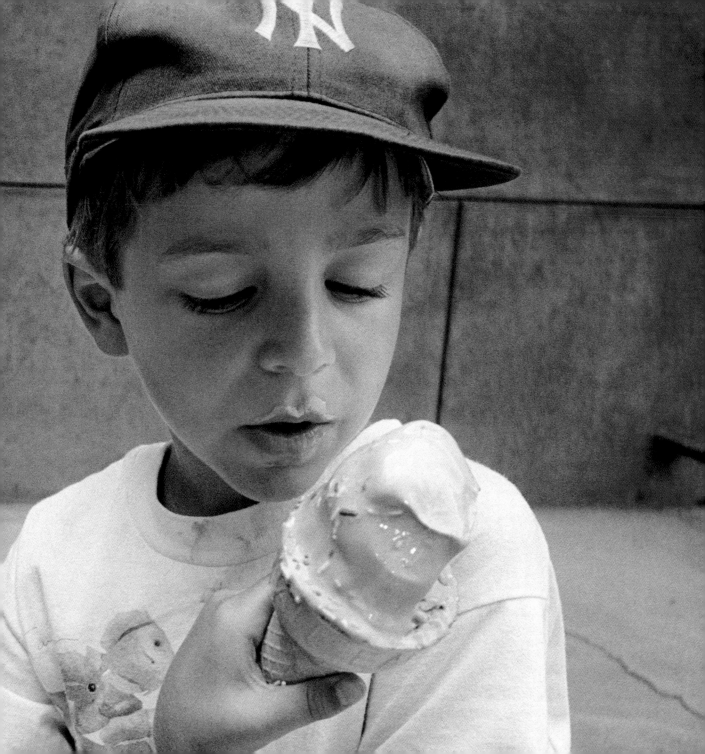

D<small>OGS MAKE LITTLE OF OUR</small>

M<small>USIC</small> *but scent is as obscure to us.* ❊

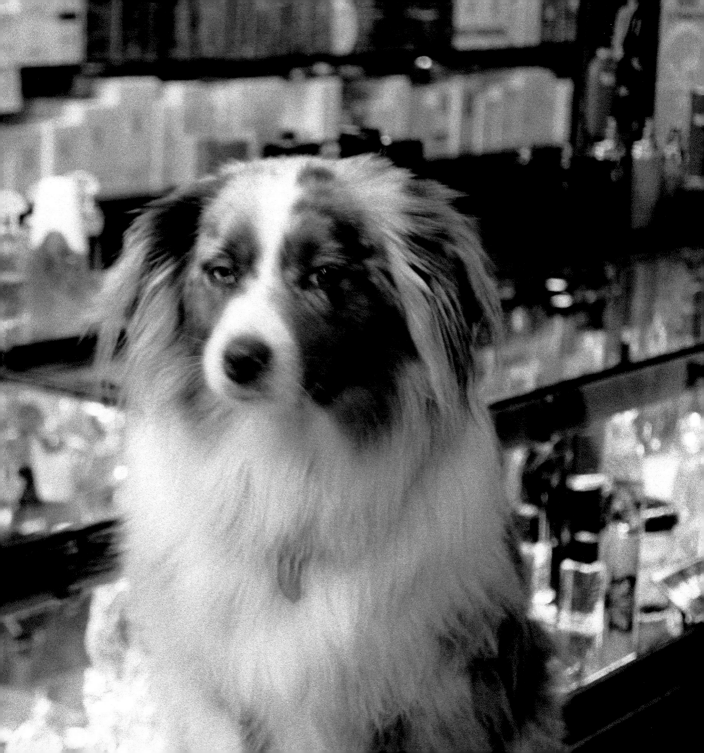

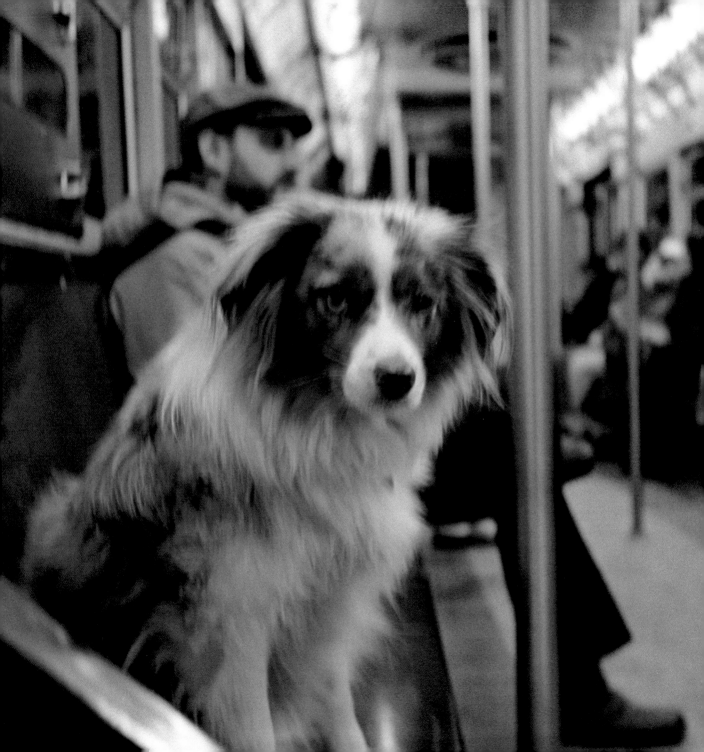

To lose a dog's trust is to FAIL THE SOUL. ❋

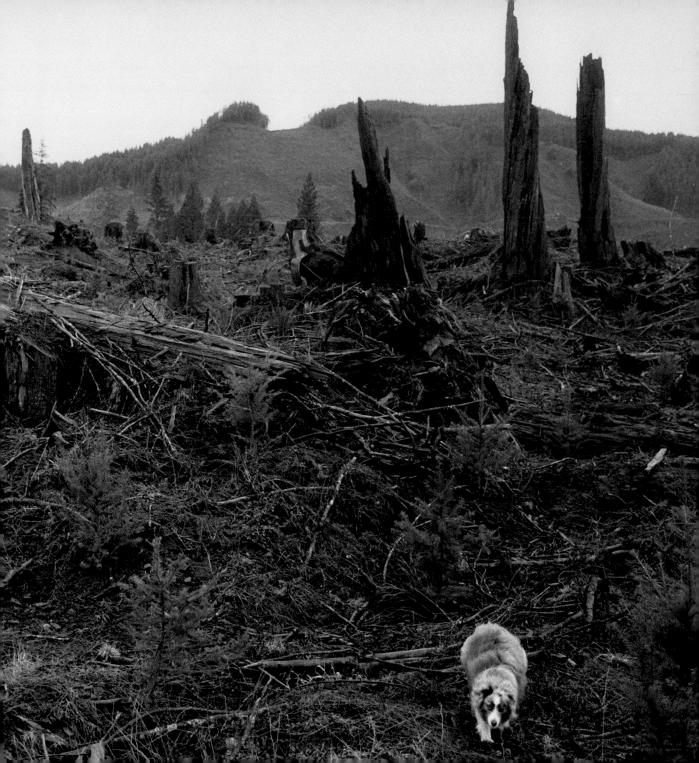

PROVOKED, *even a patient dog will throw herself into fury with* CLEAR BODILY JOY. ❈

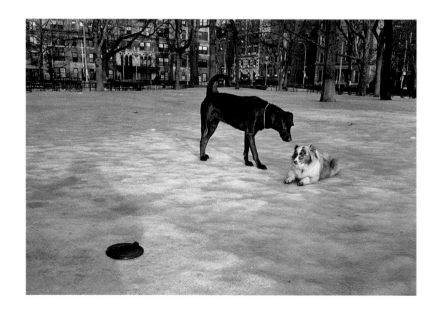

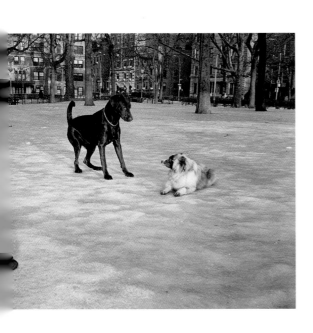
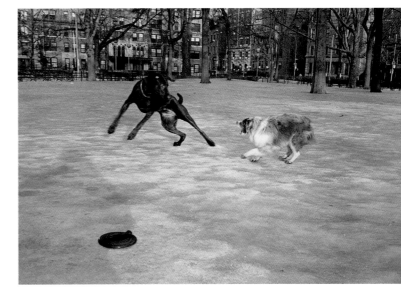

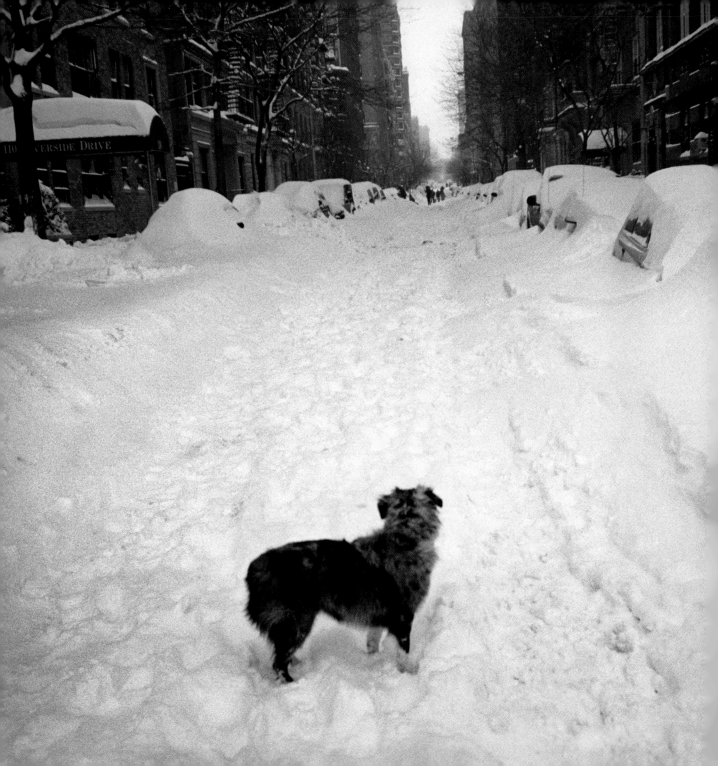

THEY DO NOT HAVE OUR NEED TO PIN DOWN THE CONSTELLATIONS—*dogs do not tell those kind of stories.* ❄

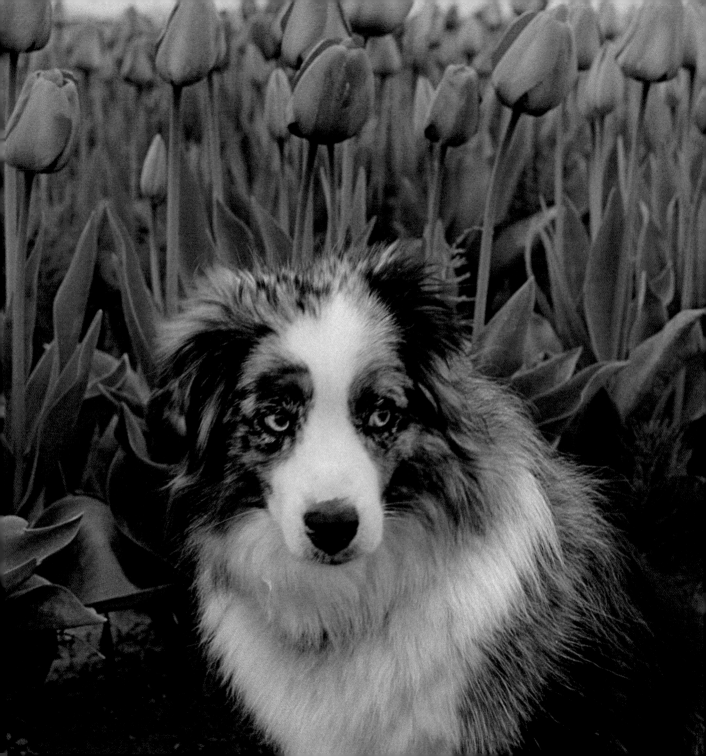

THEY HAVE NOT ENTIRELY

PUT AWAY THEIR WILDNESS,

their animal desire to let wind flow

through them. ❋

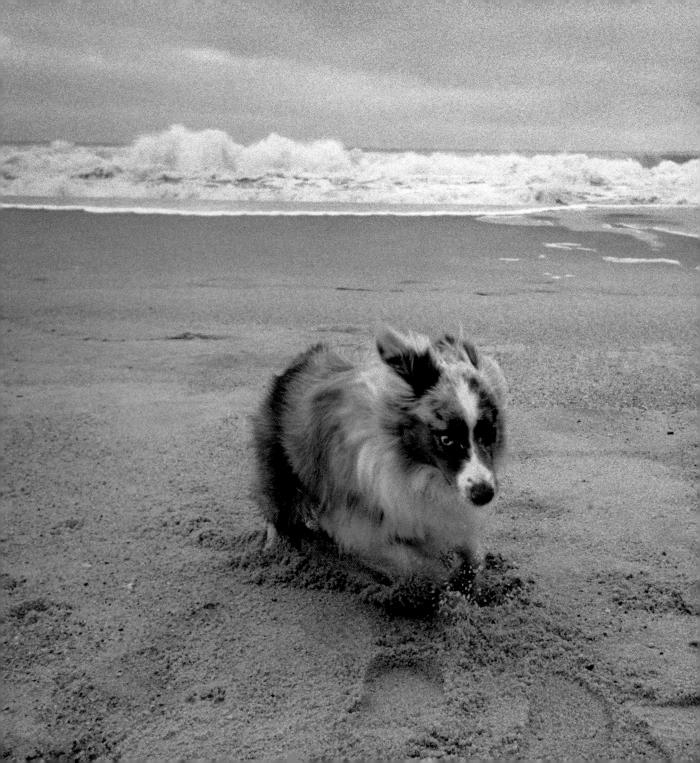

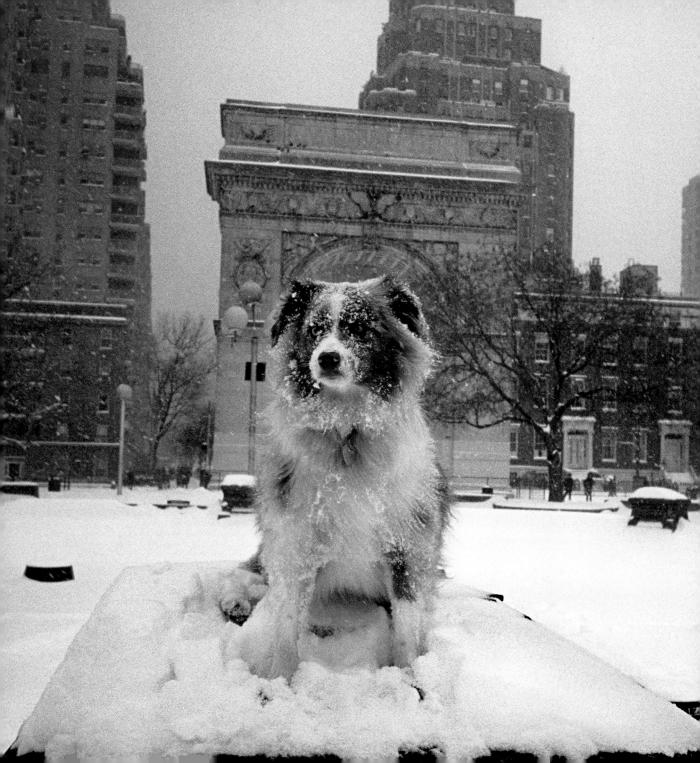

SOME DOGS HAVE A GENIUS FOR JOY, *some for friendship, and some for the wisdom of* BEING FULLY IN THE WORLD. ✳

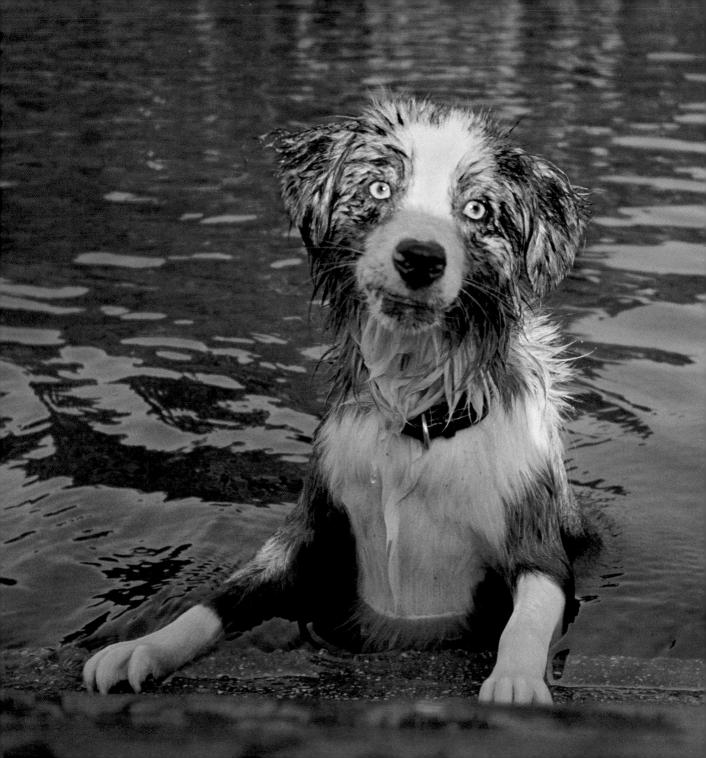

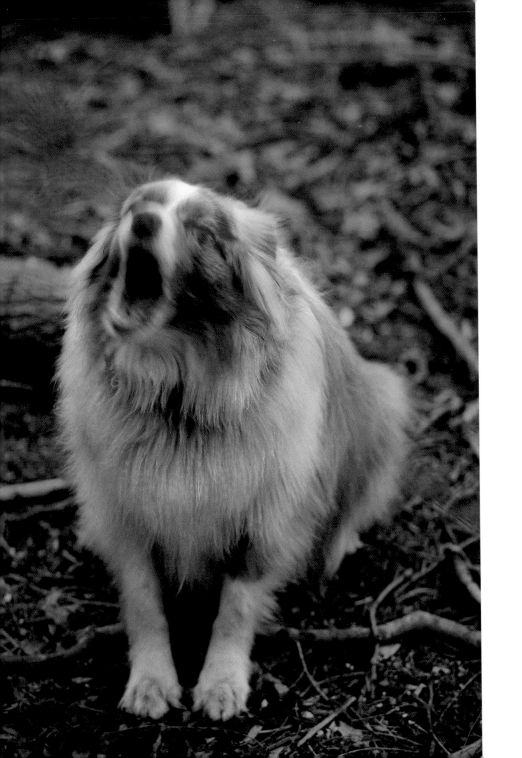

When a dog speaks, it is not language

BUT PURE FEELING

GIVEN VOICE. ❋

DOGS WANT WHAT THEY WANT—

INTENSELY, IMMEDIATELY, *in the*

absolute now and forever.

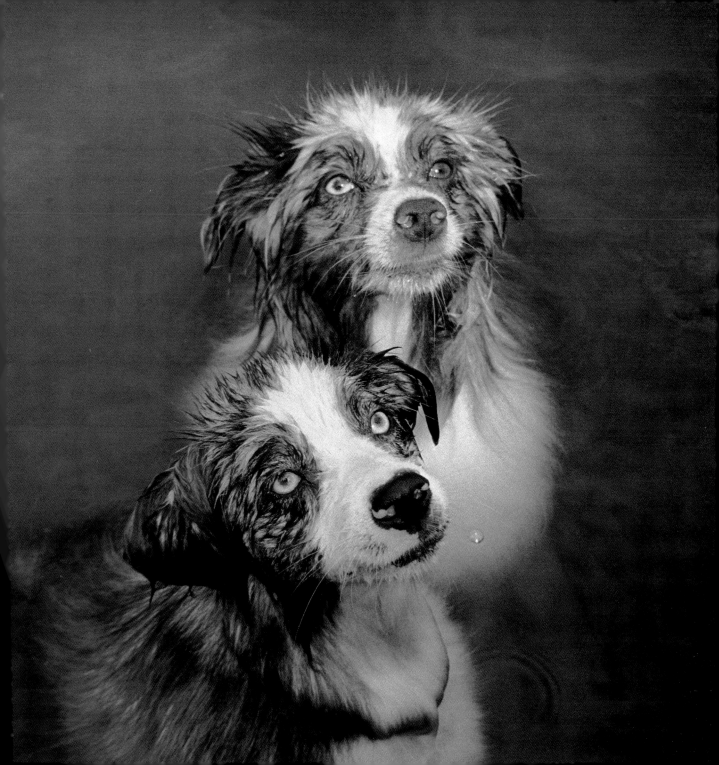

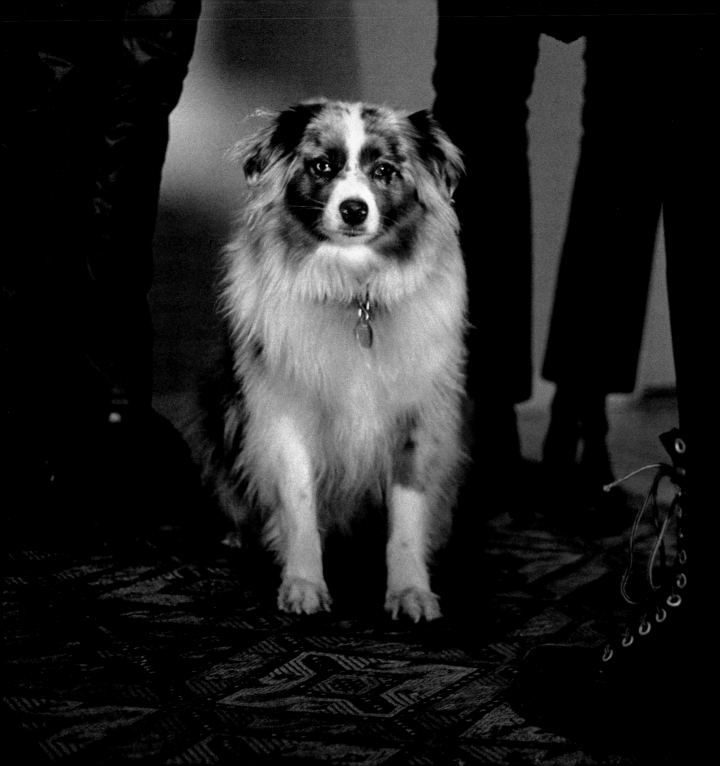

FROM DOWN HERE, SAYS THE DOG,

the Rich and Famous look like everybody else—

JUST ANOTHER PAIR *of*

FASHIONABLE SHOES. ❀

When we say to each other "IT'S A DOG'S LIFE," WE MEAN EITHER THAT WE'RE LYING IN THE SUN OR THAT WE'VE BEEN SENT OUT INTO THE RAIN. ✻

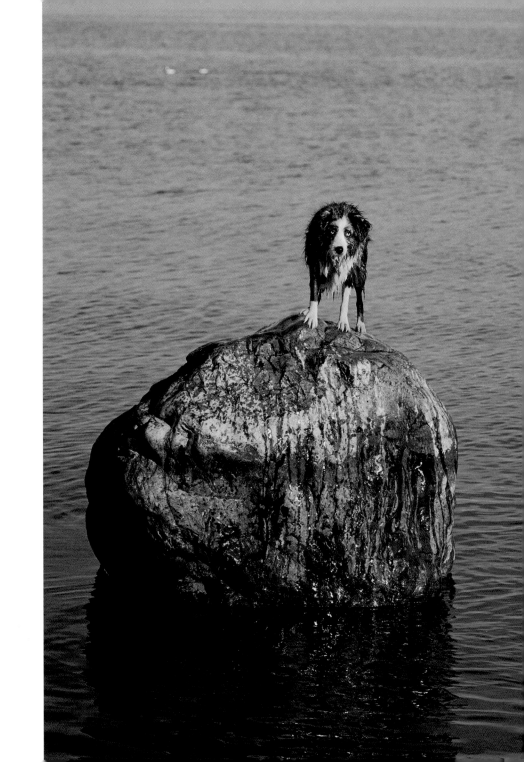

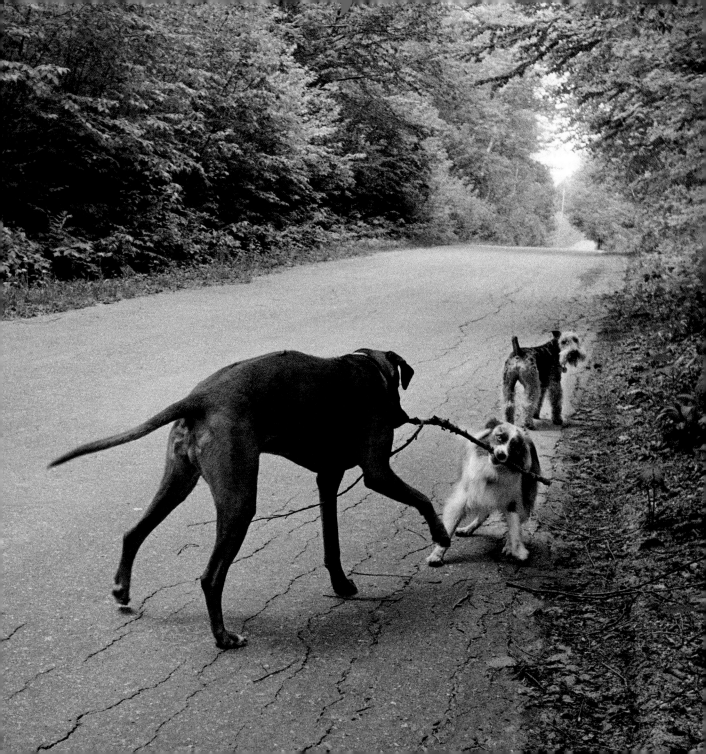

A DOG WILL RUN IN CIRCLES

OR CHASE STICKS ENDLESSLY

NOT OUT OF MINDLESSNESS

but from energy and delight in her existence. ❄

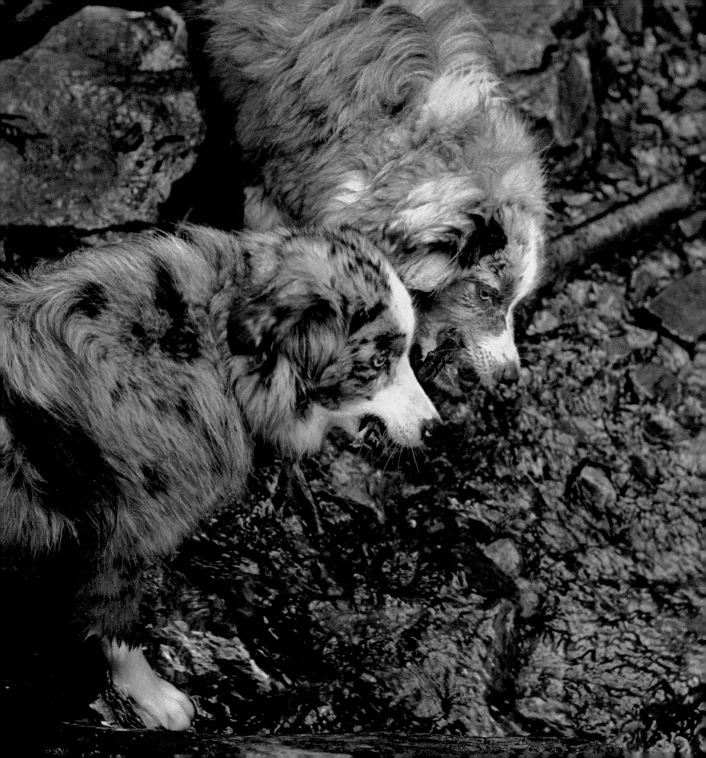

DOGS KNOW THE WORLD

CANNOT BE DESCRIBED

FROM ANY ONE POSITION—

that everything must be explored

by many circumnavigations. ❊

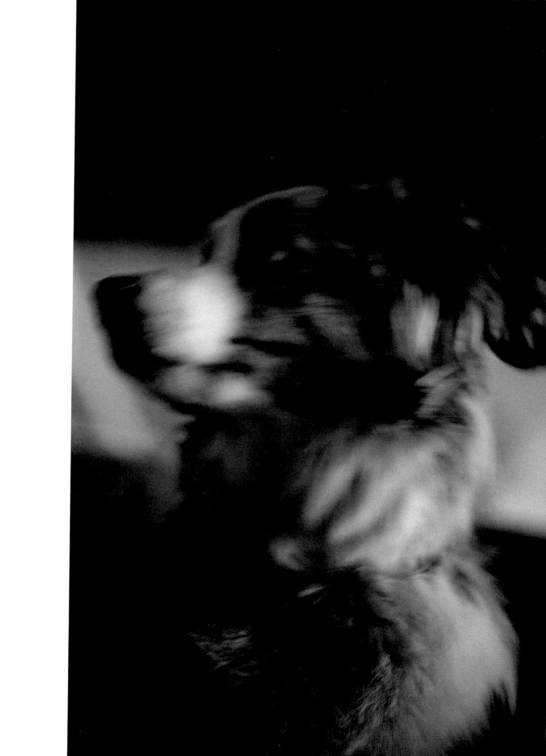

THERE IS NOTHING SO PURE

AS A DOG'S GREETING: *it is the*

definition of honesty. ❋

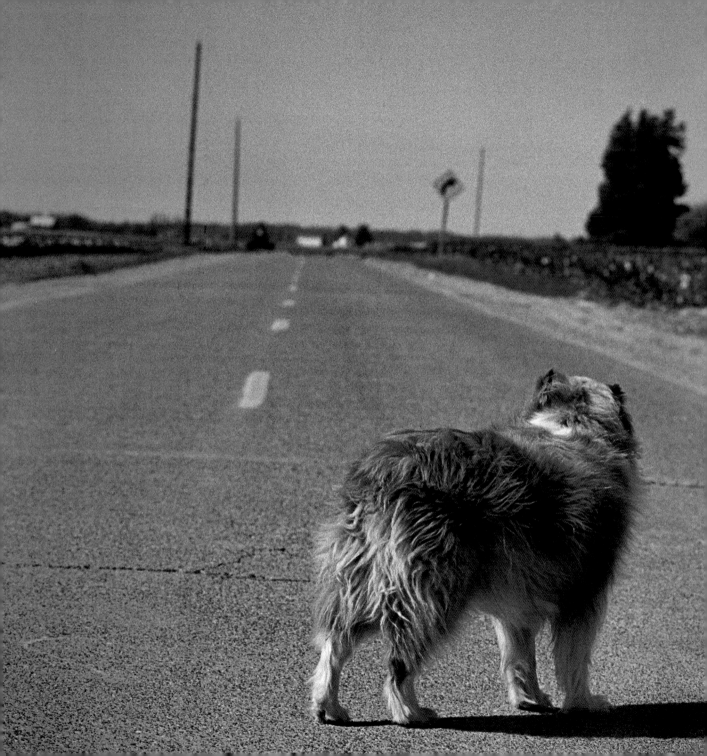

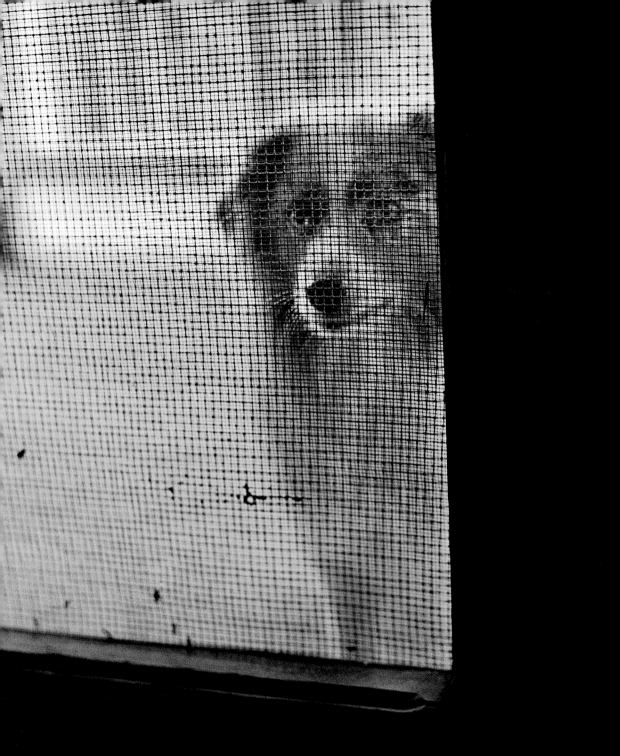

Most dogs are intelligent enough to be

driven crazy by neglect, whether from

ignorance or malice; most, too, are

good enough to forget bad handling

WHEN RESPECTED *for* THEIR

PARTICULAR CAPACITIES. ❋

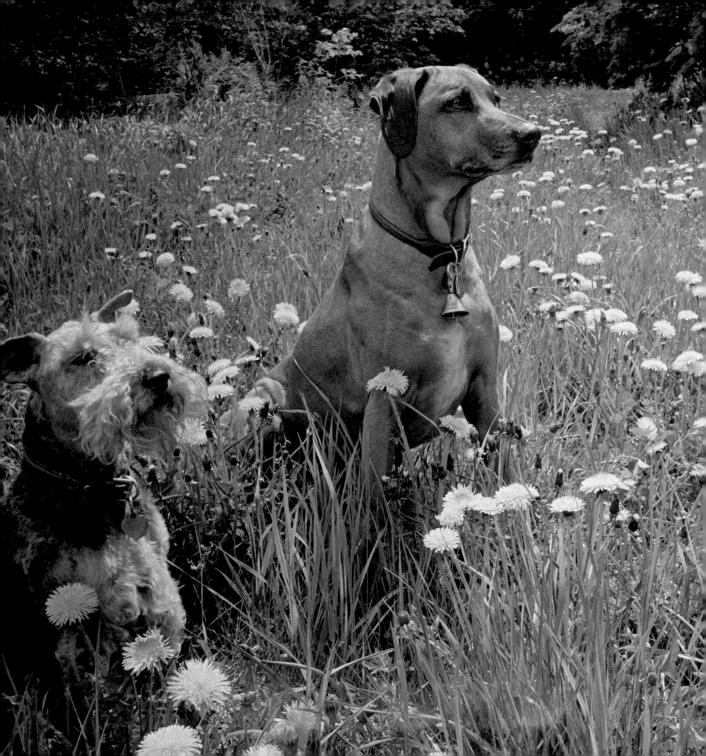

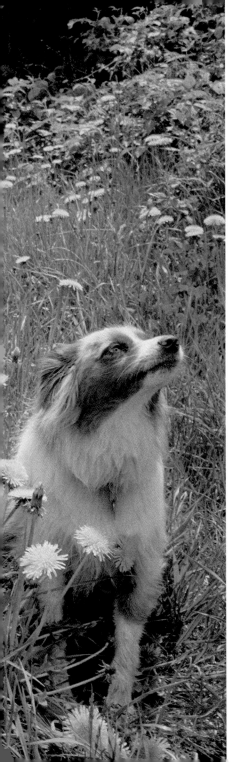

How does the great dane recognize the dachshund as kin? *We have no idea.* ❈

A dog walking down a path SEES EVERYTHING WE DON'T AND NOT MUCH THAT WE DO. ❄

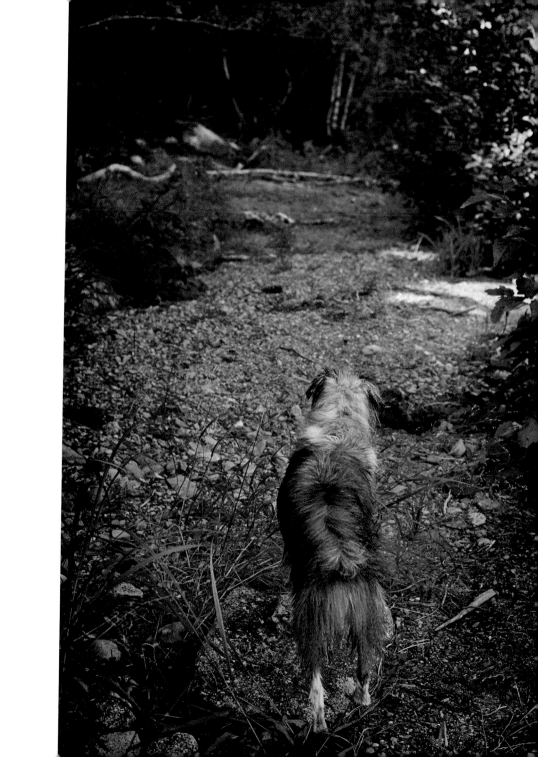

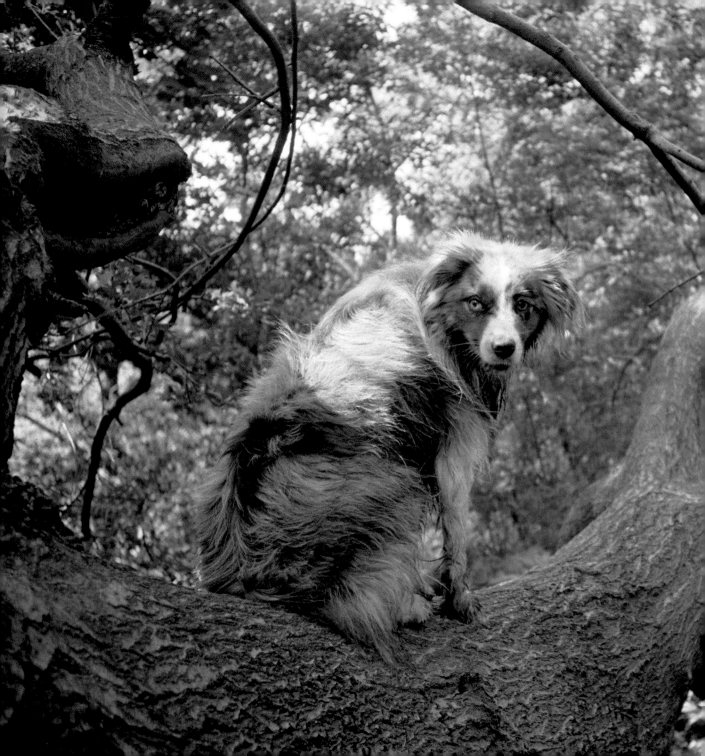

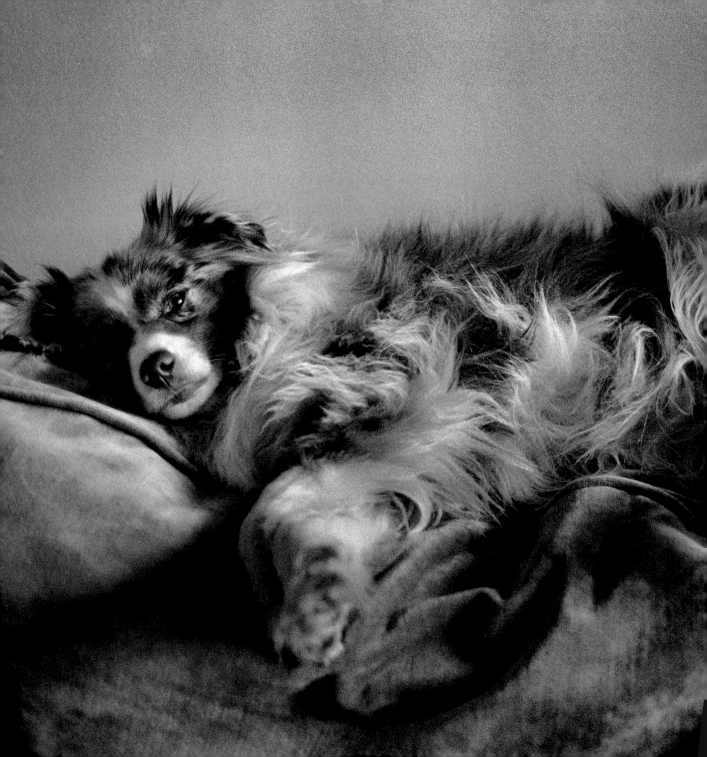

DOGS SLEEP SO MUCH BECAUSE THEY HAVE TO, *having sacrificed their energy to join us in the places we now live*, HAVING COME SO FAR. ❄

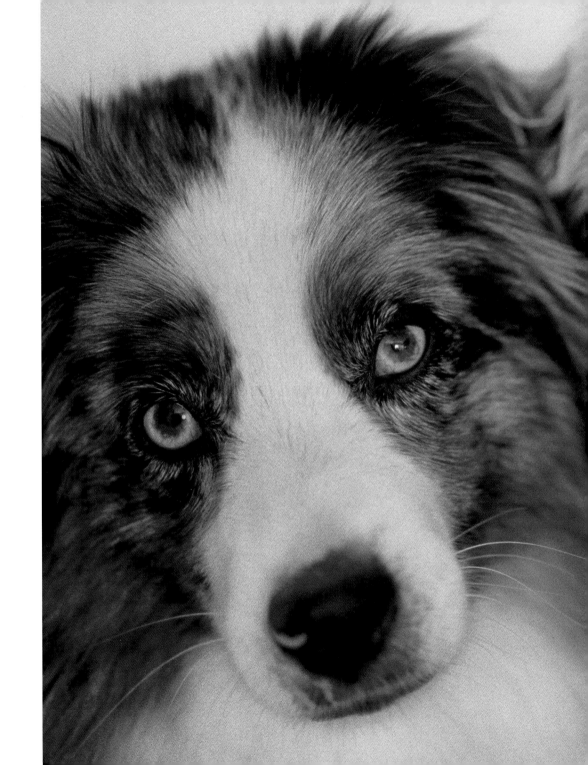

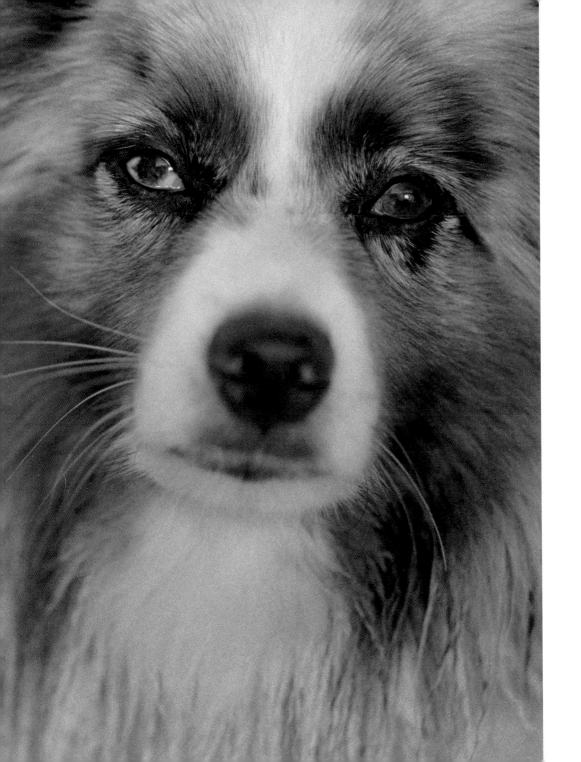

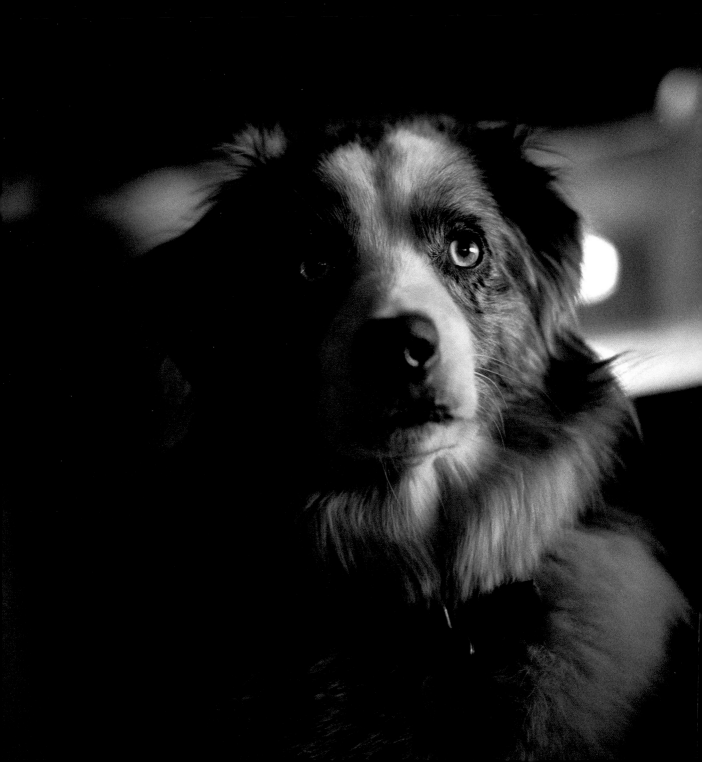

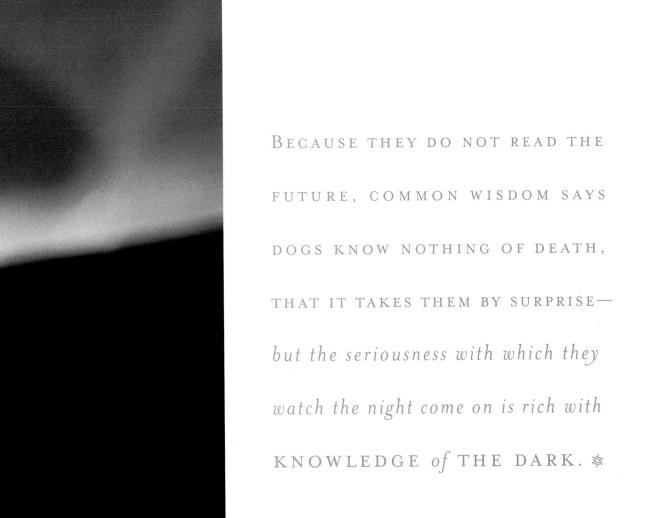

BECAUSE THEY DO NOT READ THE
FUTURE, COMMON WISDOM SAYS
DOGS KNOW NOTHING OF DEATH,
THAT IT TAKES THEM BY SURPRISE—
but the seriousness with which they
watch the night come on is rich with
KNOWLEDGE *of* THE DARK. ❋

Paradise might be to LIVE INSIDE A DOG'S DREAM. ❀

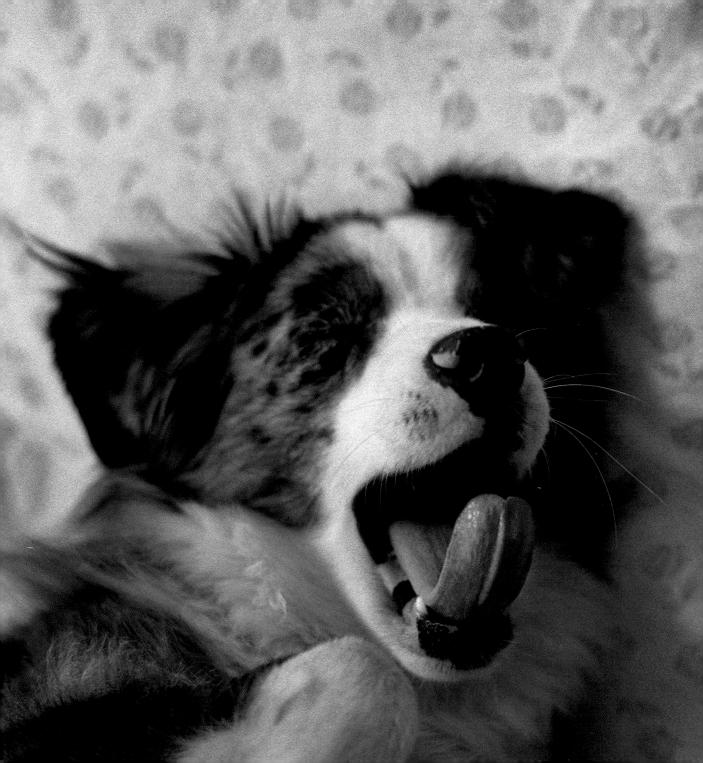

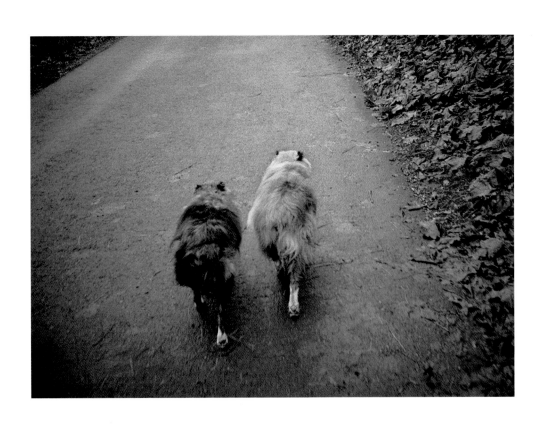